The Impressionist Masters

grayscale coloring book

Curated by
Tabz Jones

Impressionism is a 19th-century art movement characterized by relatively small, thin, yet visible brush strokes, open composition, emphasis on accurate depiction of light in its changing qualities (often accentuating the effects of the passage of time), ordinary subject matter, inclusion of movement as a crucial element of human perception and experience, and unusual visual angles. Impressionism originated with a group of Paris-based artists whose independent exhibitions brought them to prominence during the 1870s and 1880s.

I invite you to visit your local museums and search the internet
to find out more about these artists.
This book is volume 4 in The Masters series of coloring books.
You can find the other volumes at most major online retailers or ask your local book
store to carry them!

The artworks in this book are public domain, I claim no copyrights to
the original works. This compilation as a whole is
copyright Tabz Jones all rights reserved.

Tabz Jones
POBox 2137
Alma, AR 72921
www.gothictoggs.net

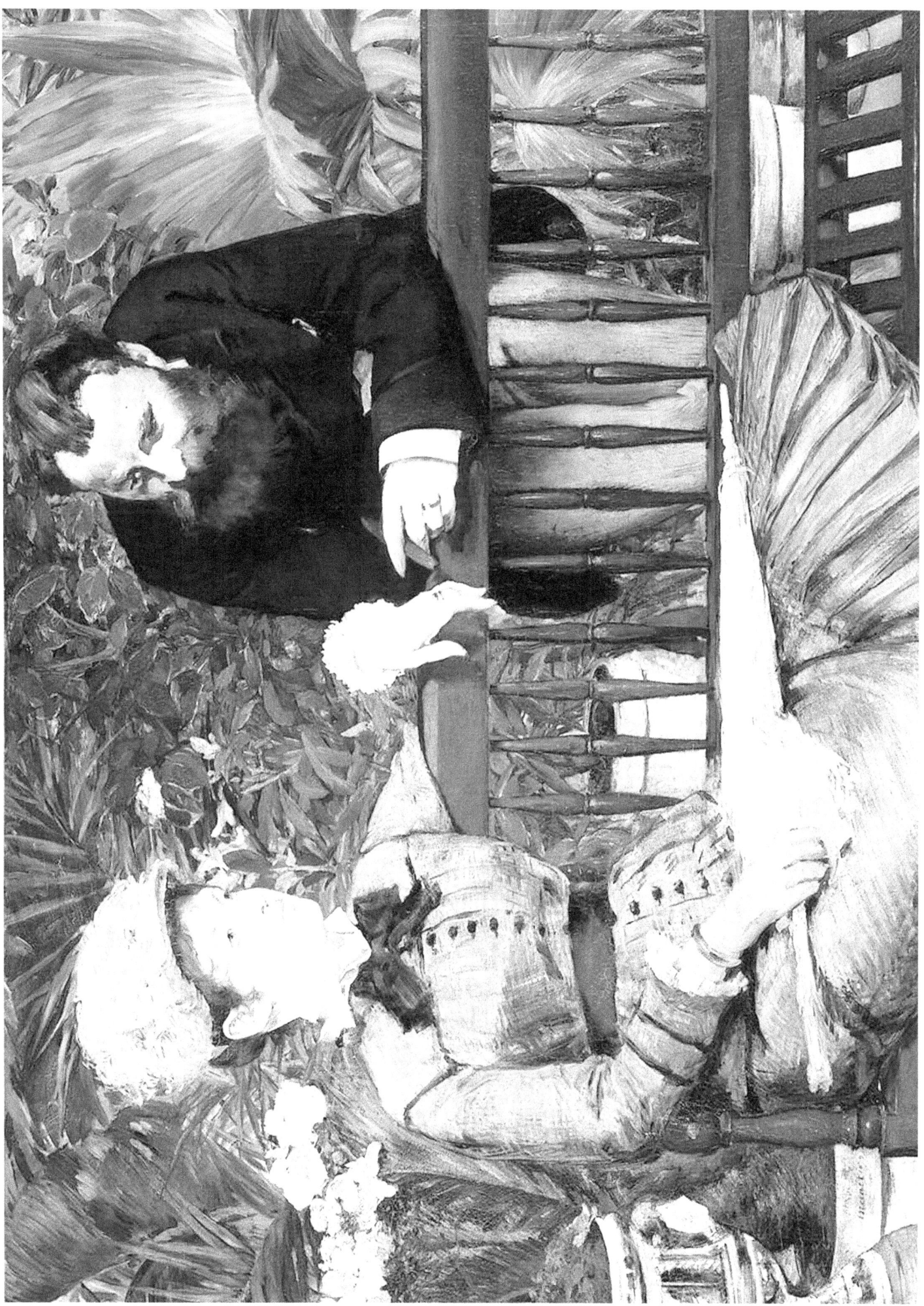

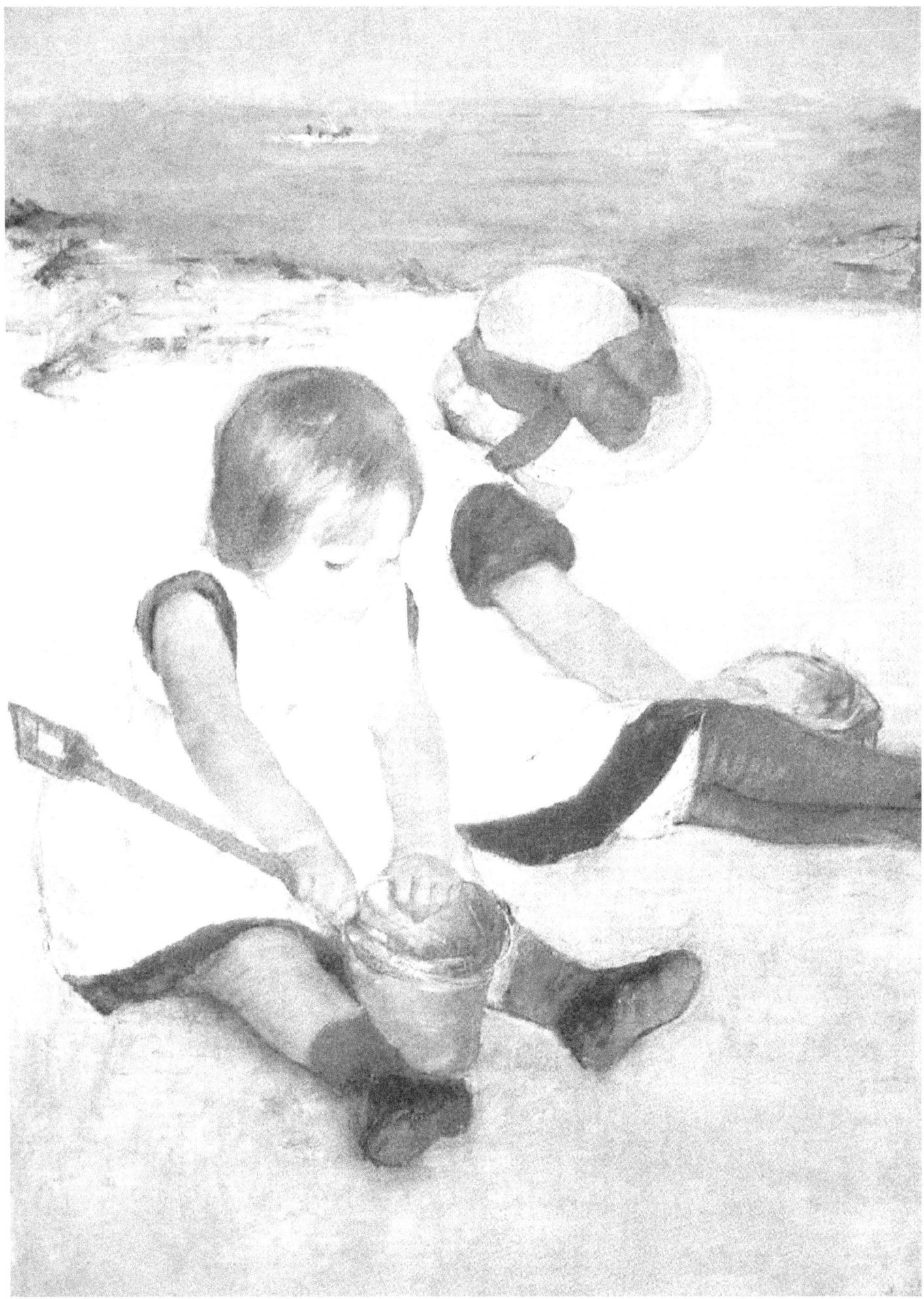

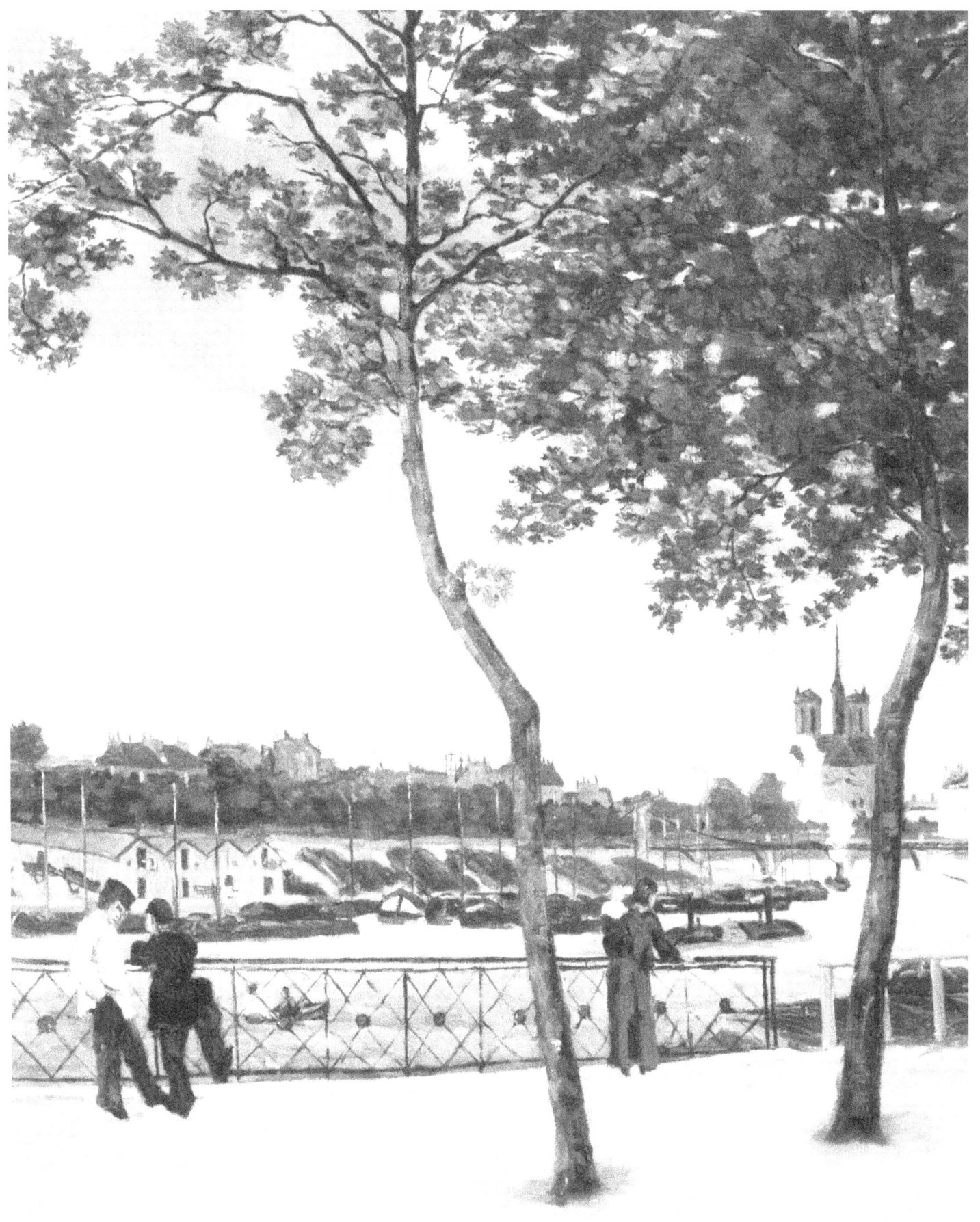

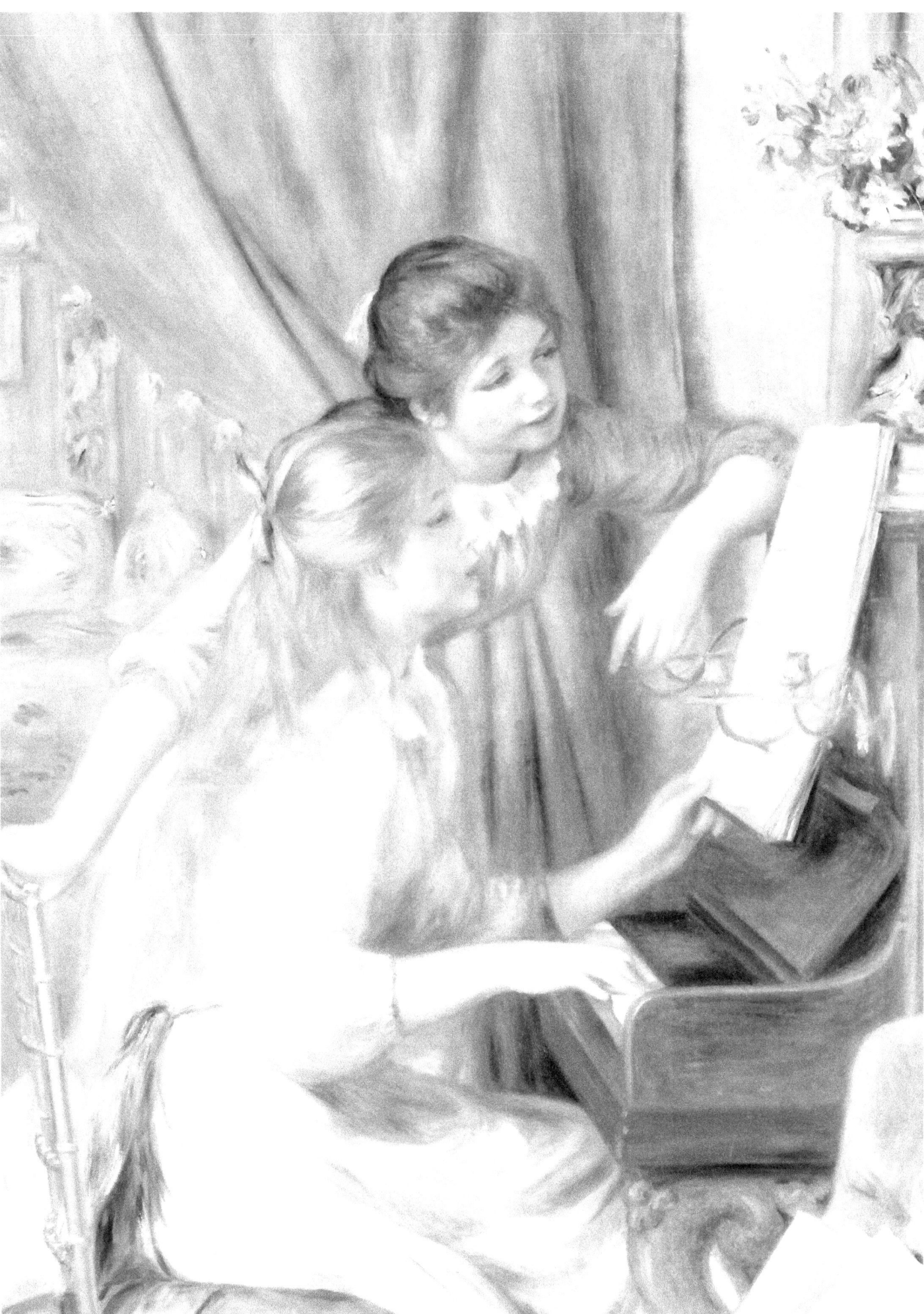

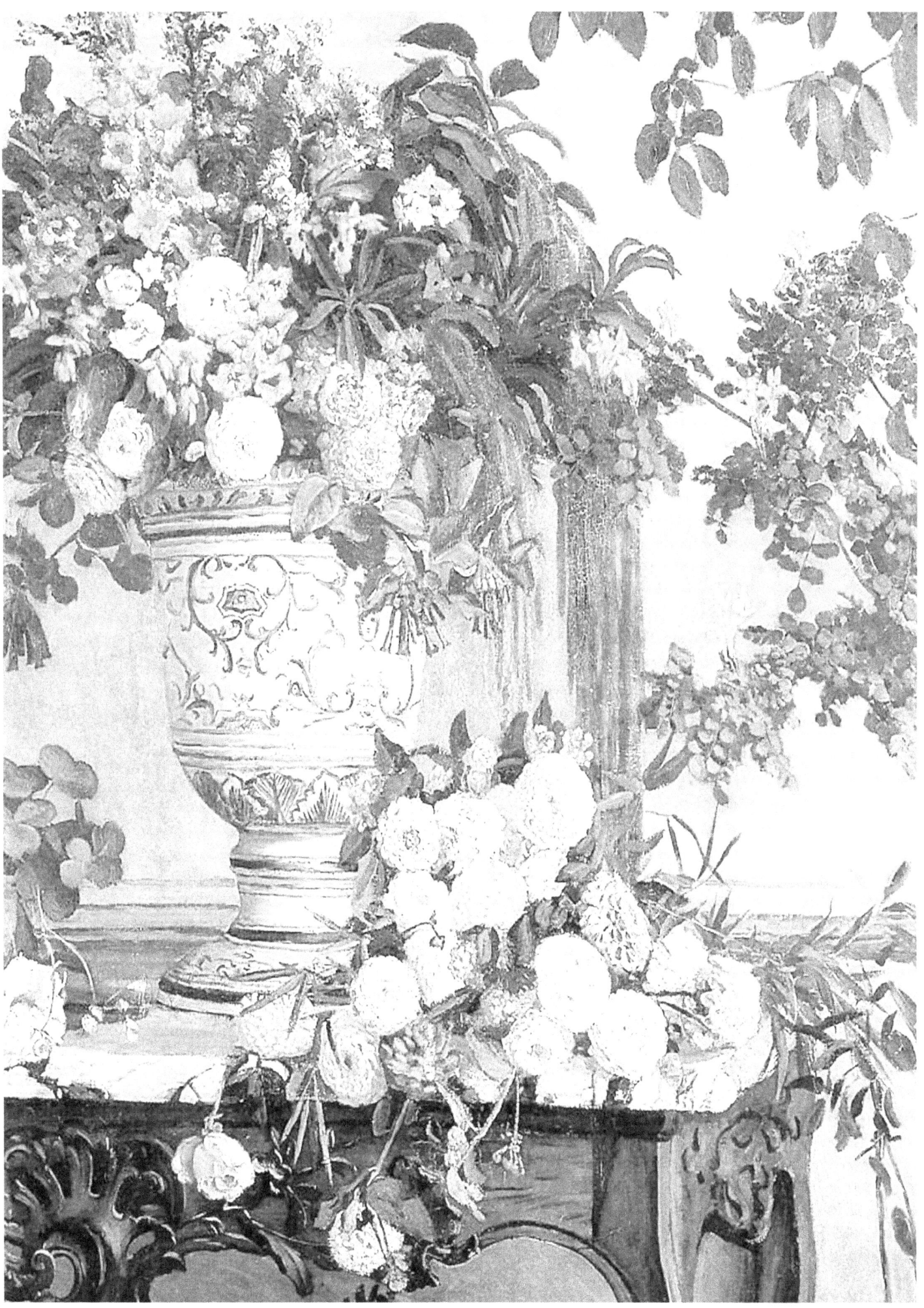

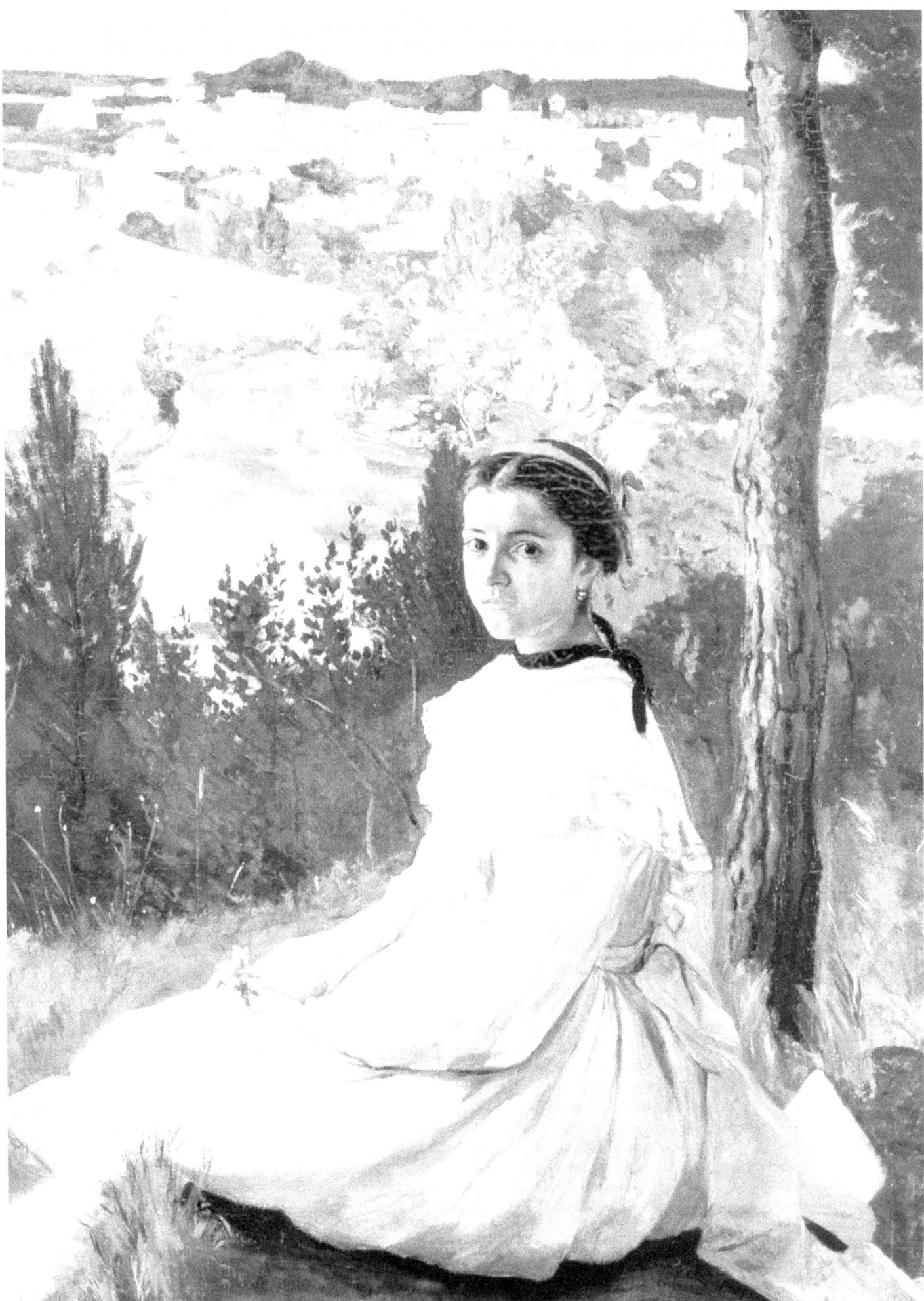

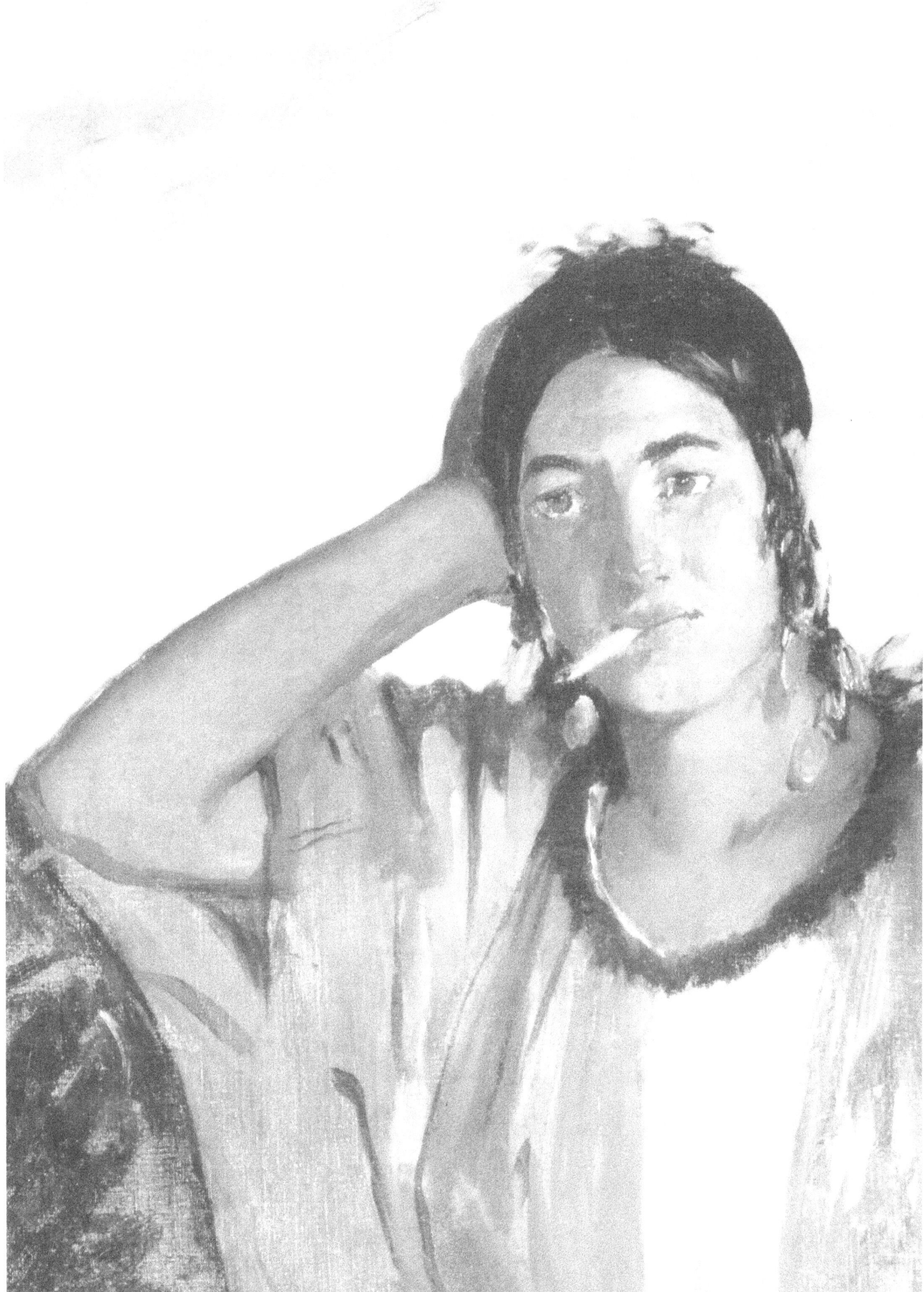

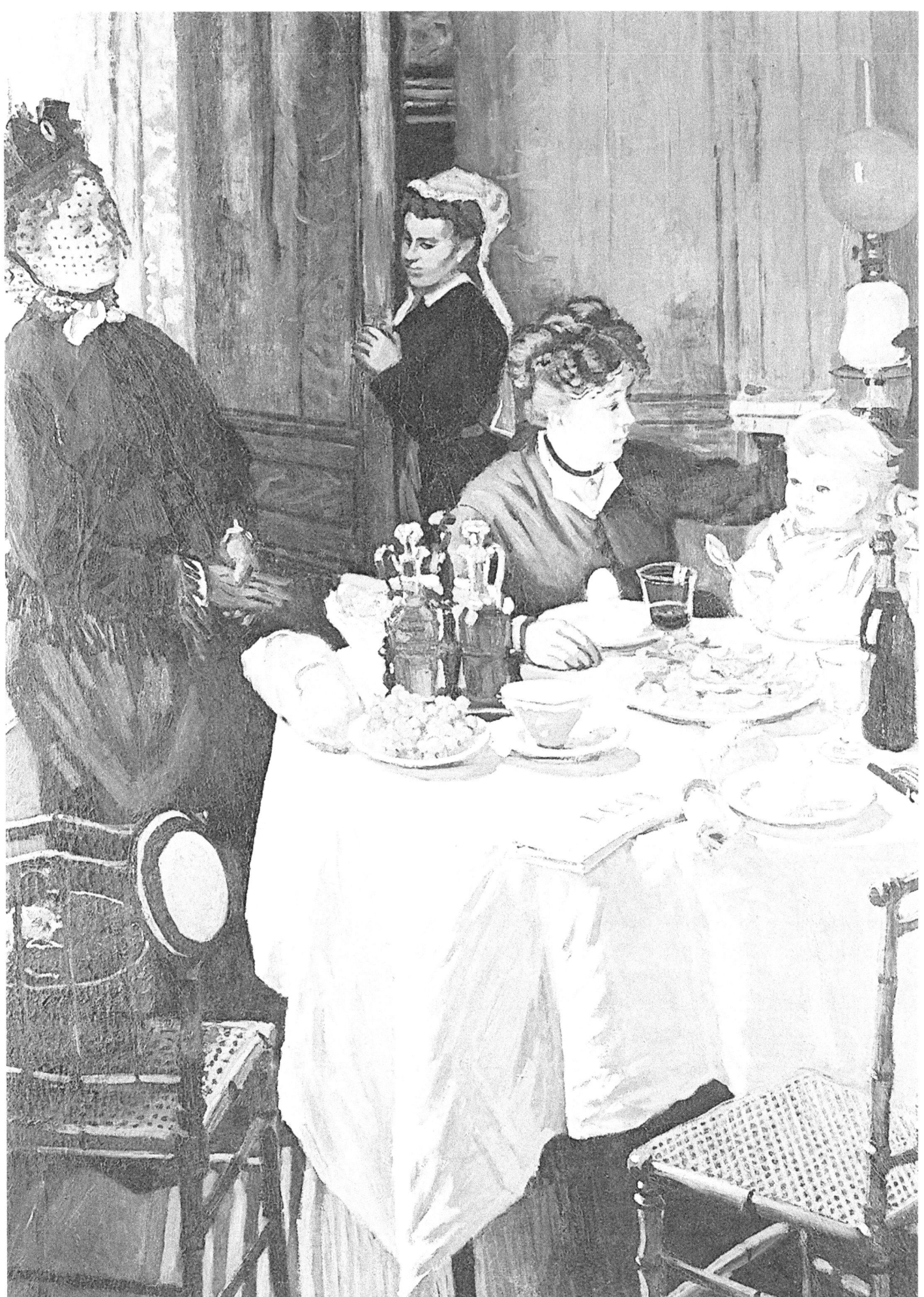

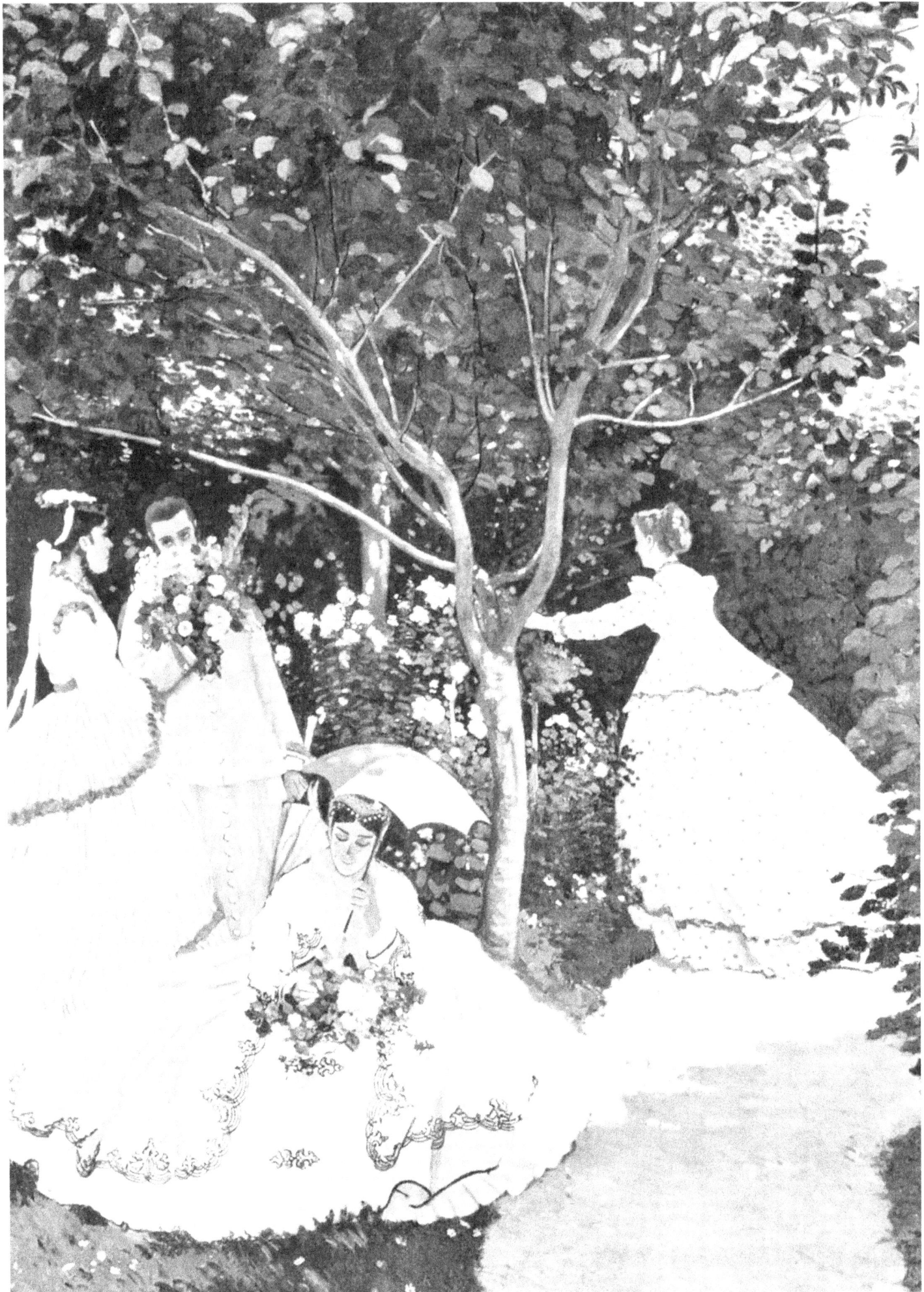

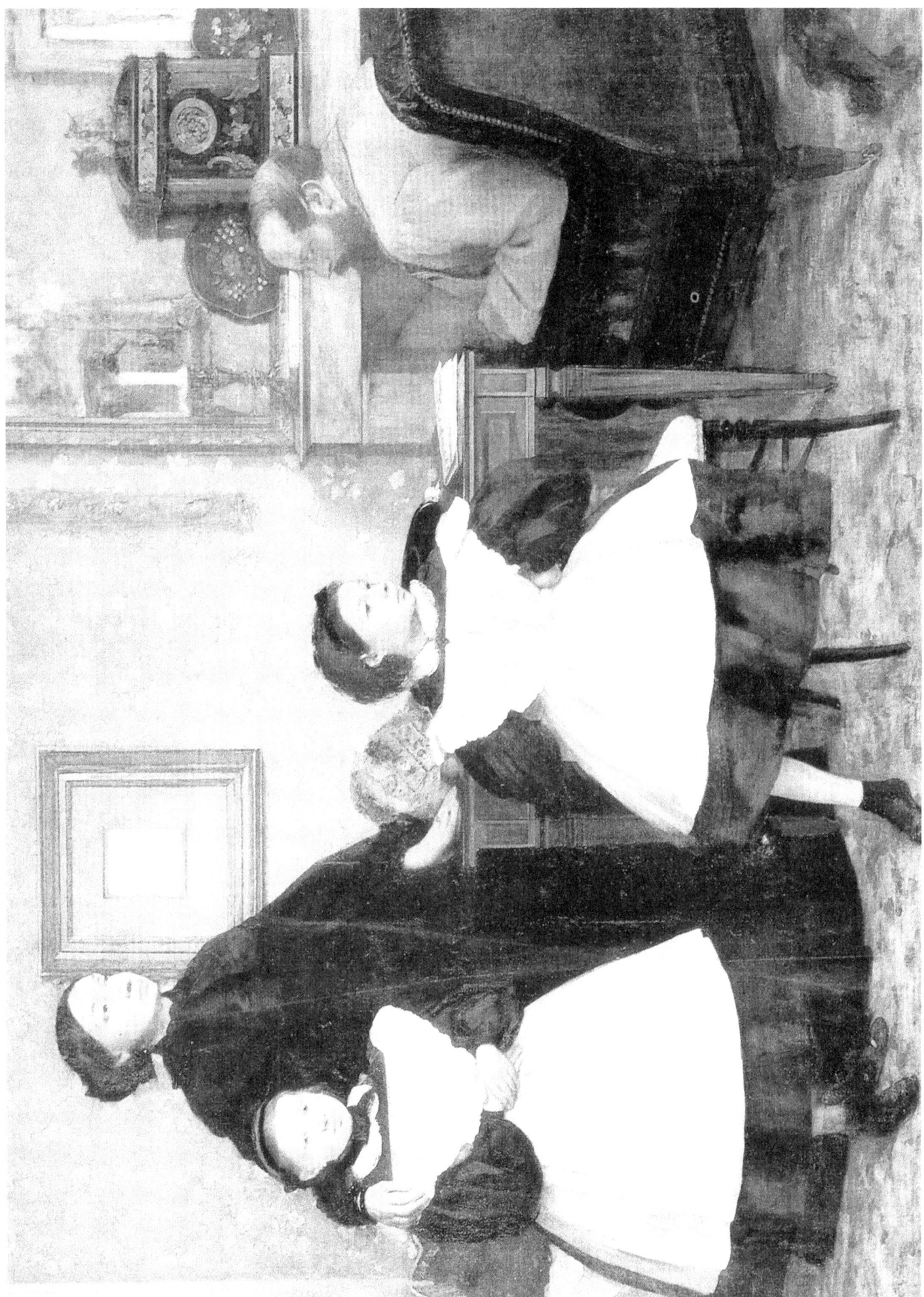

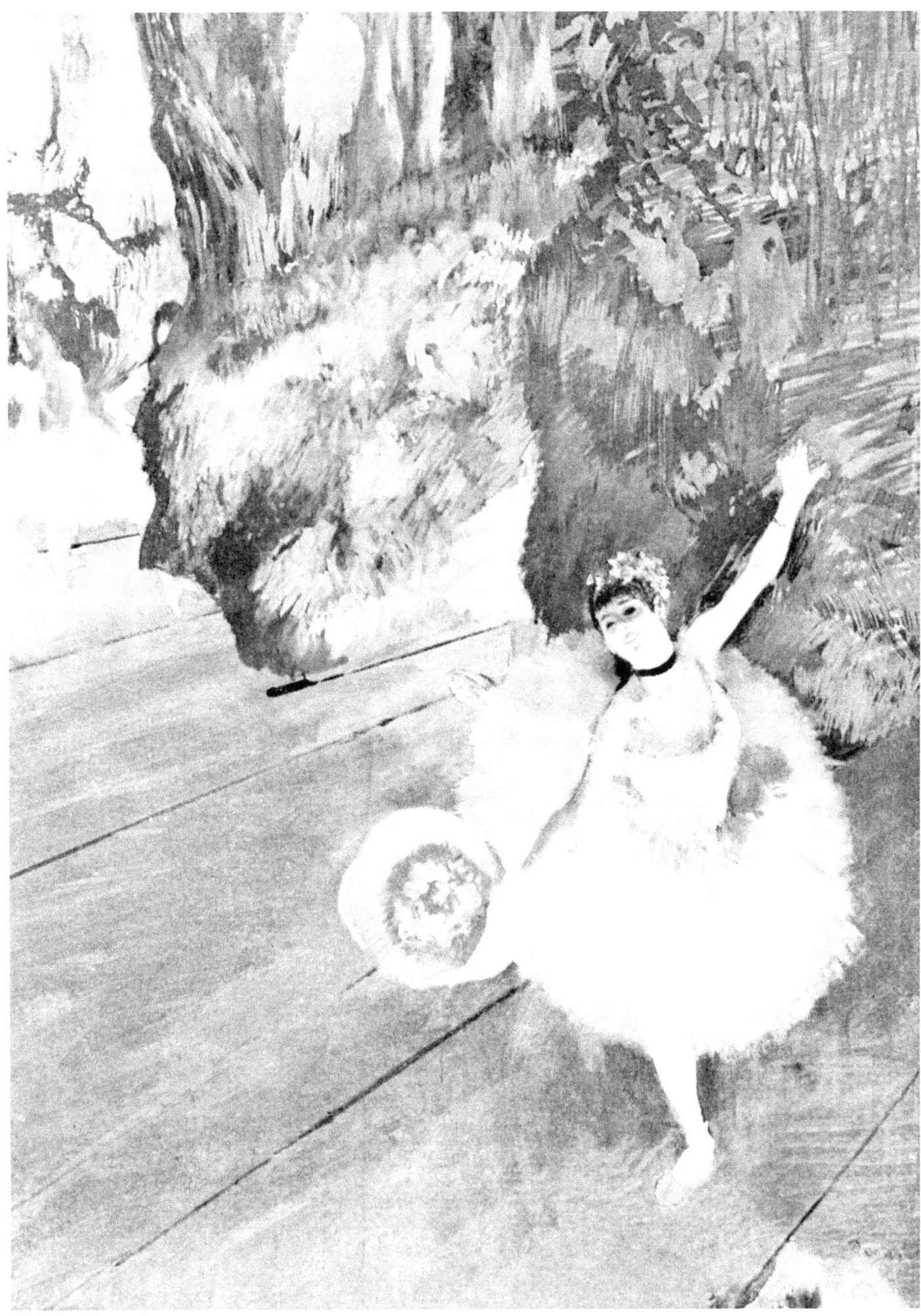

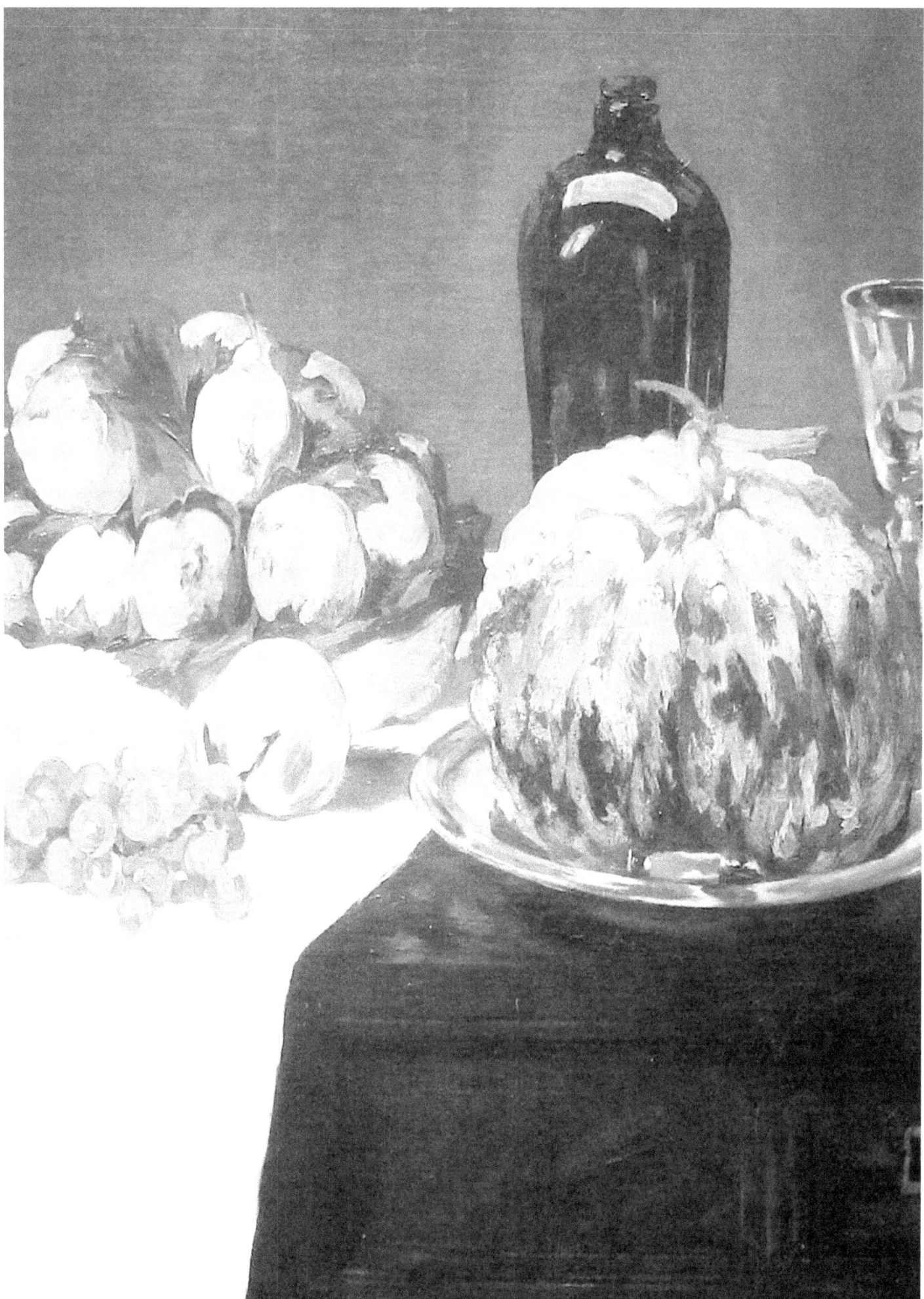

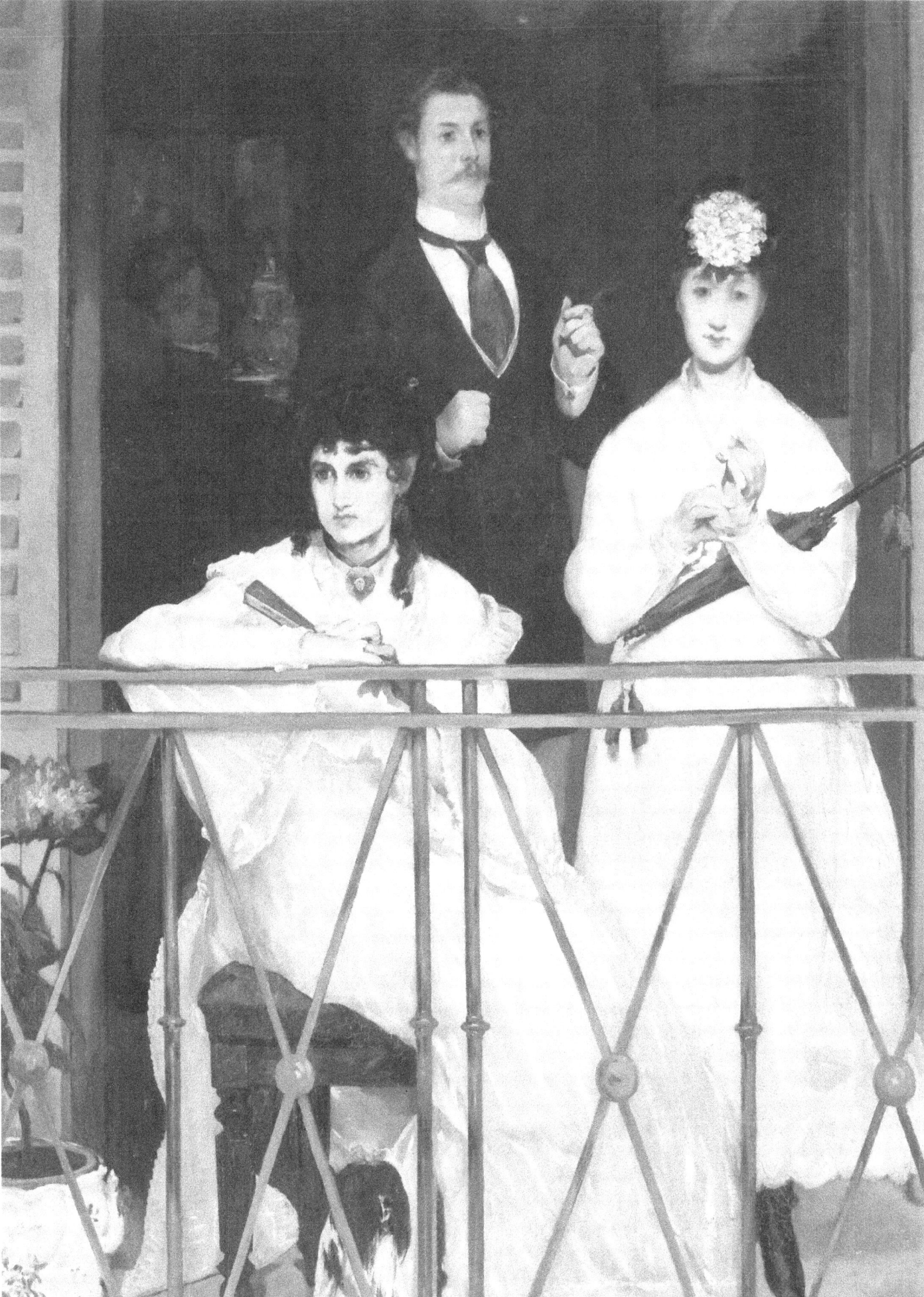

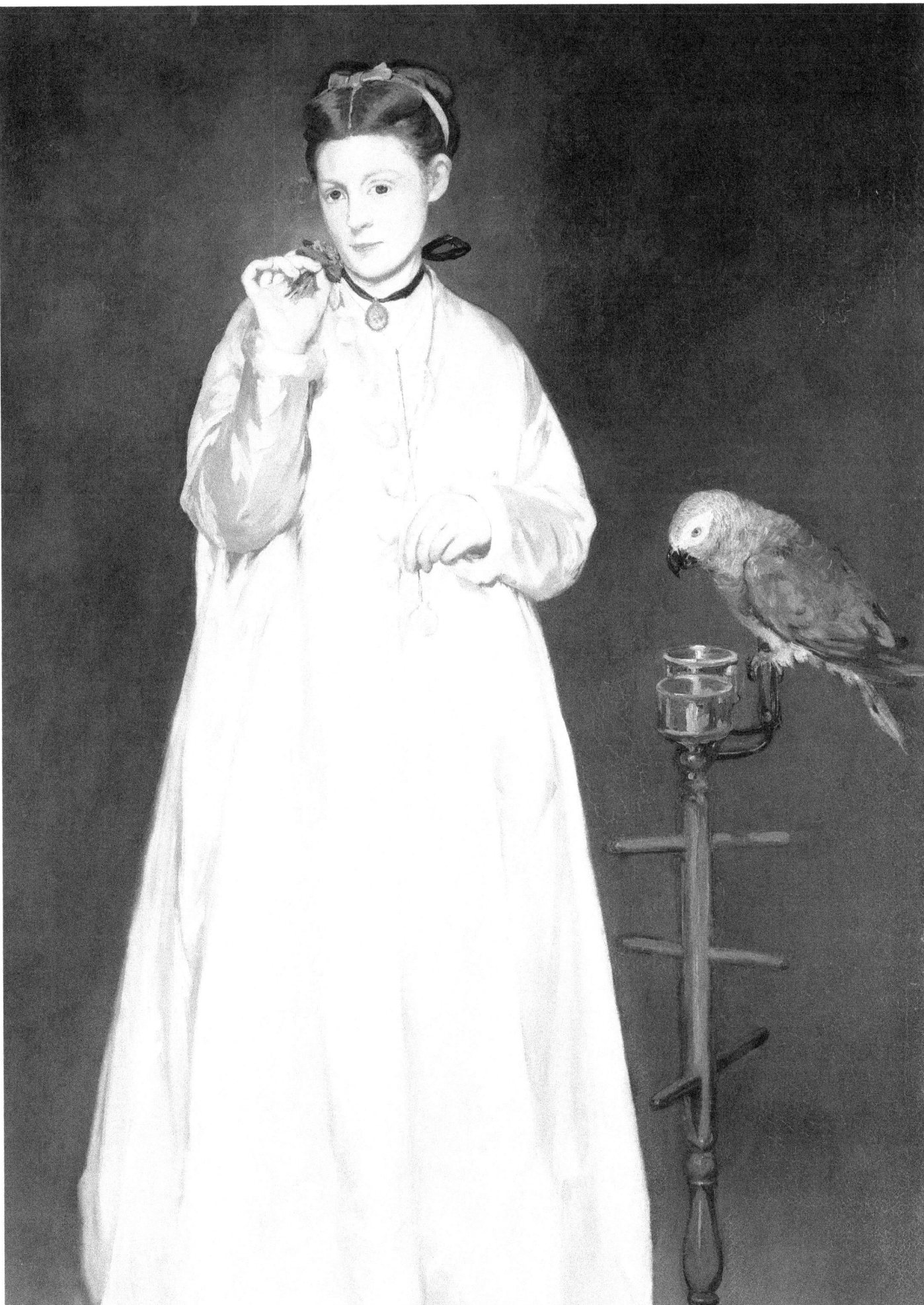

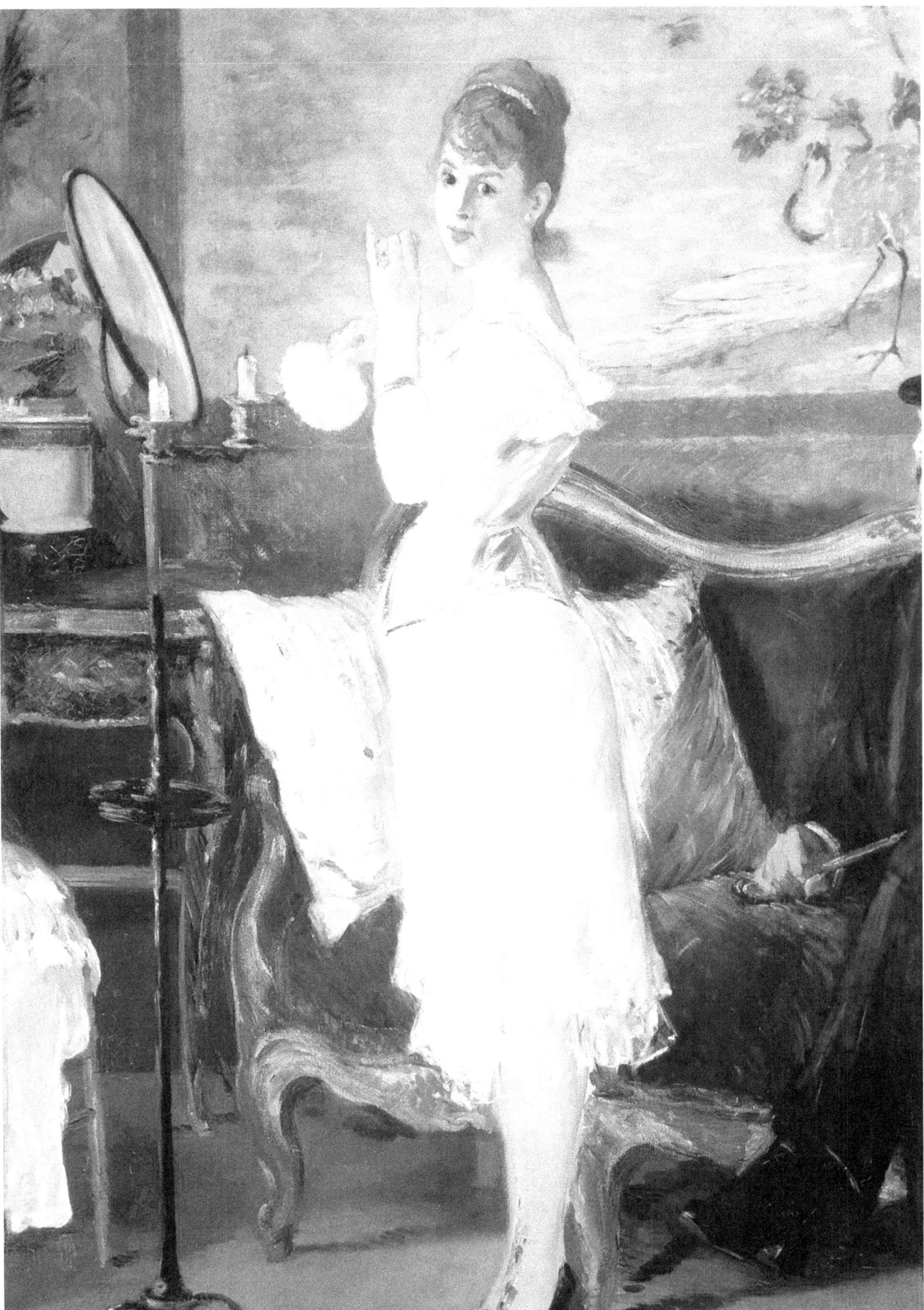

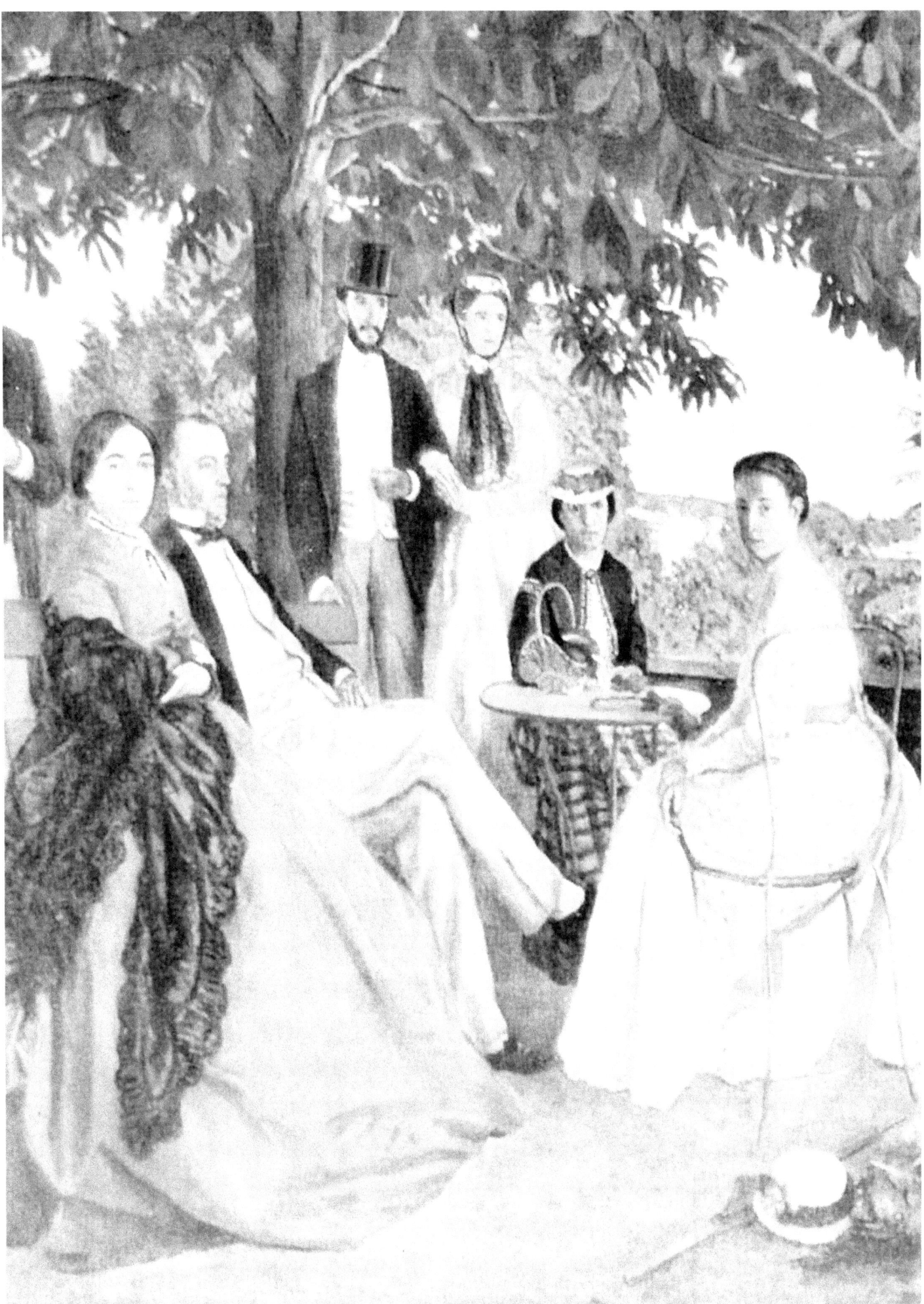

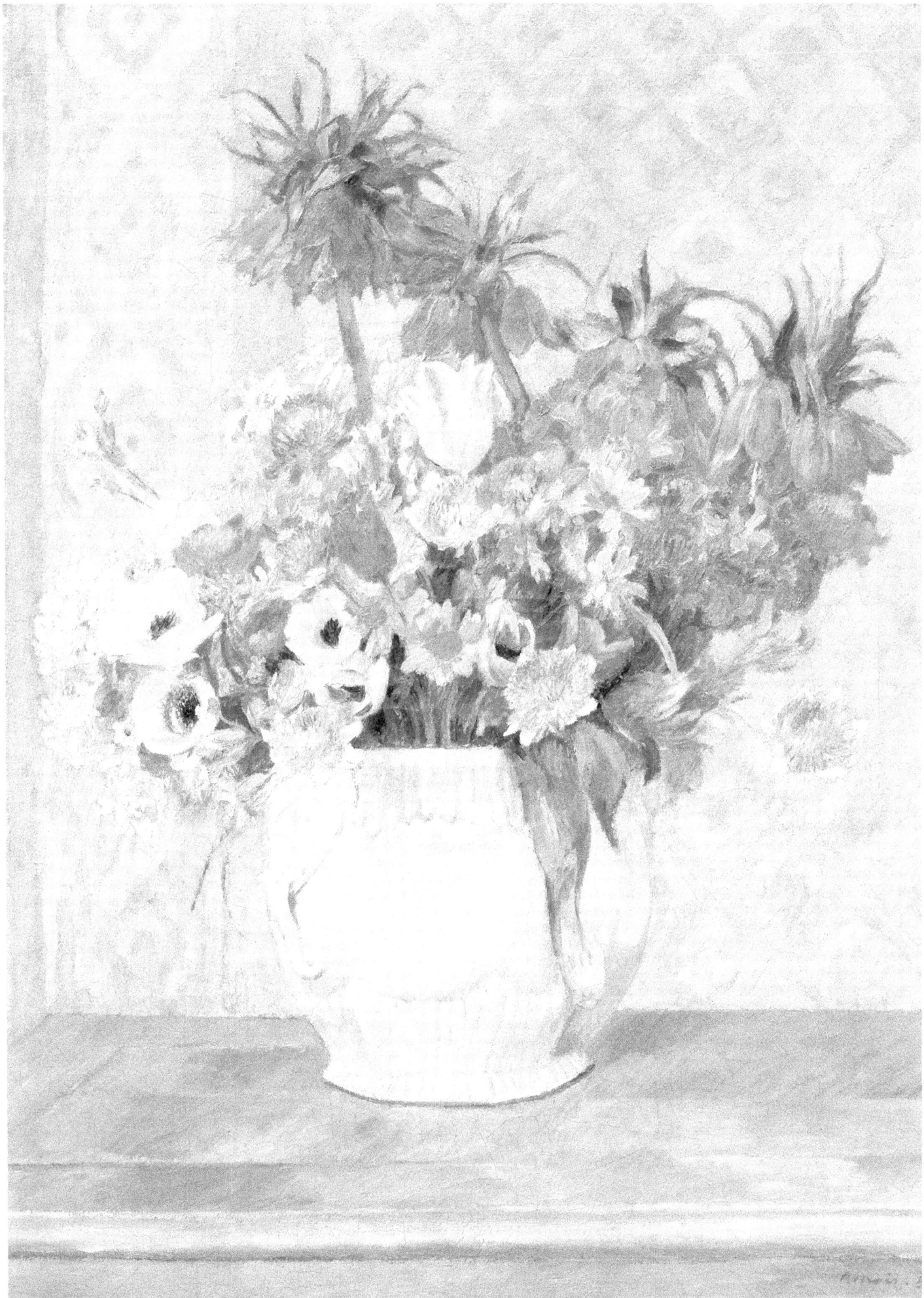

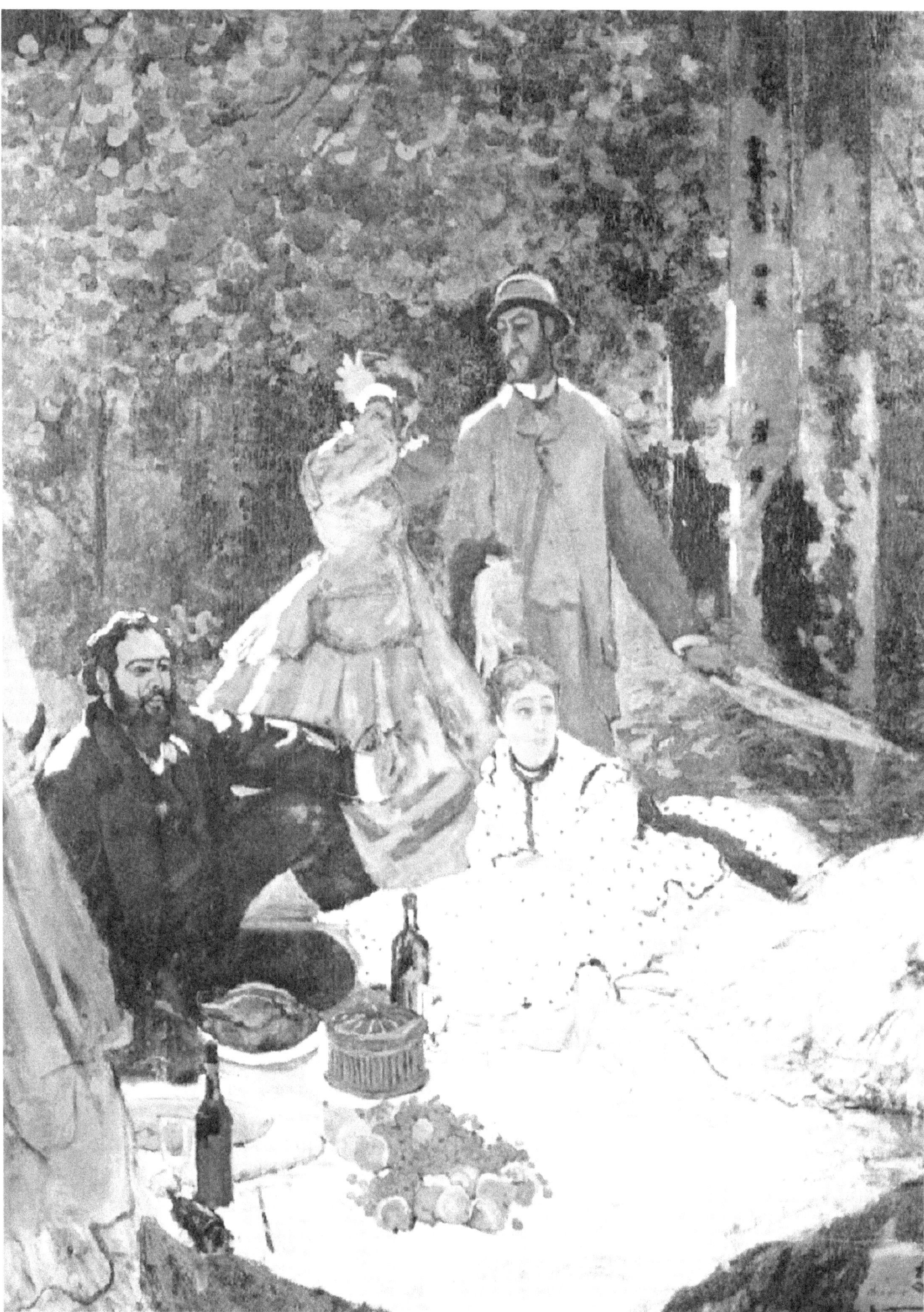

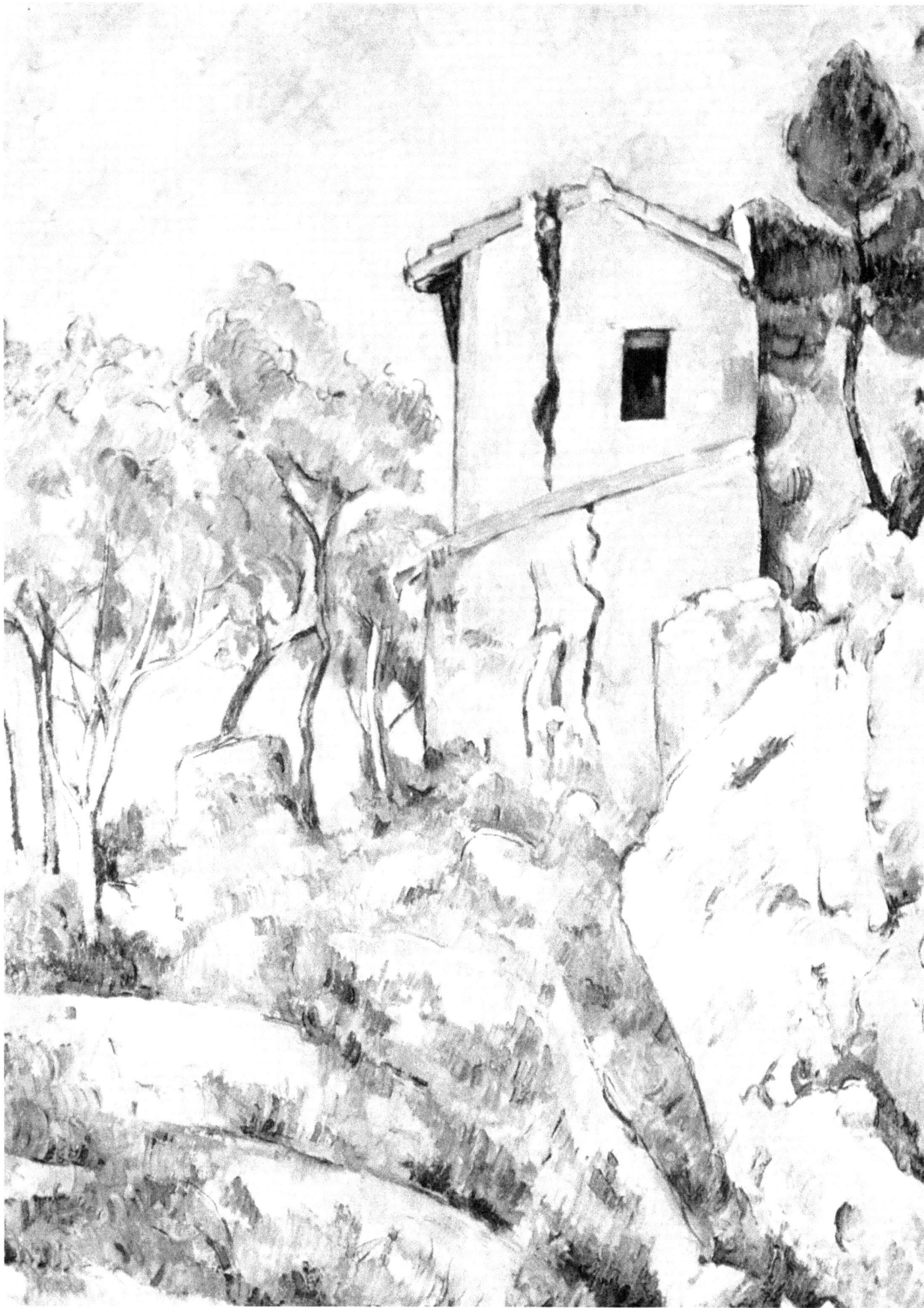

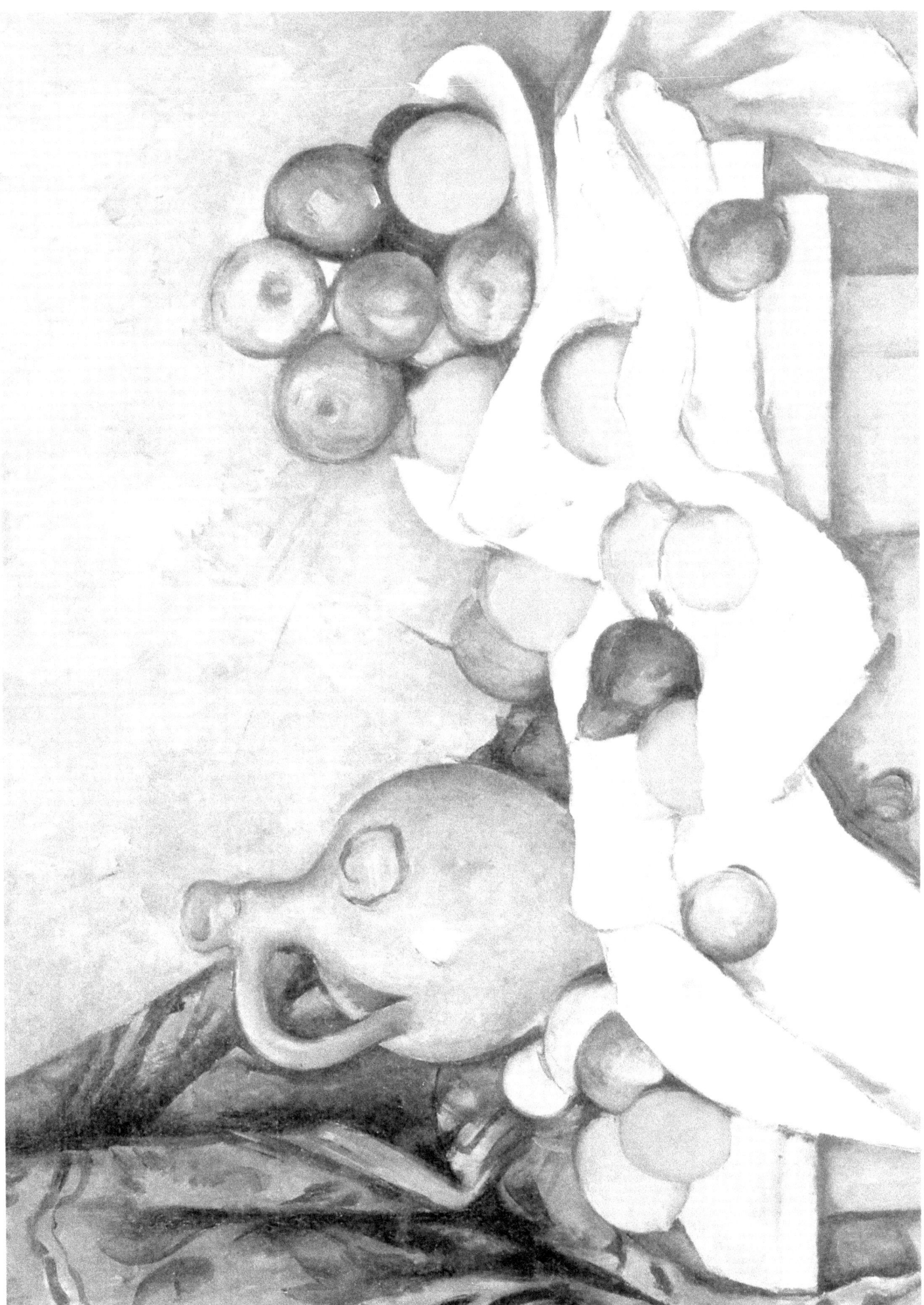

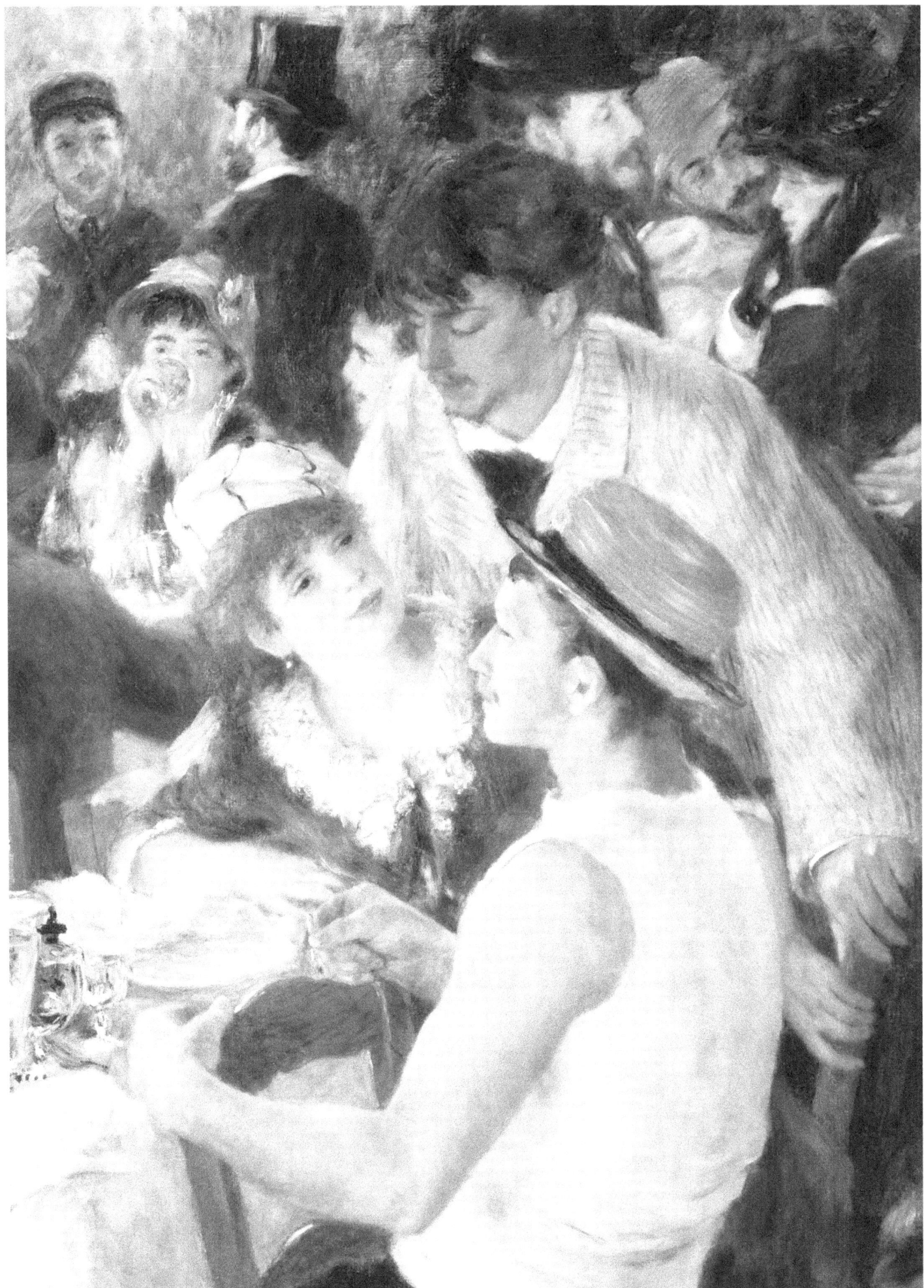

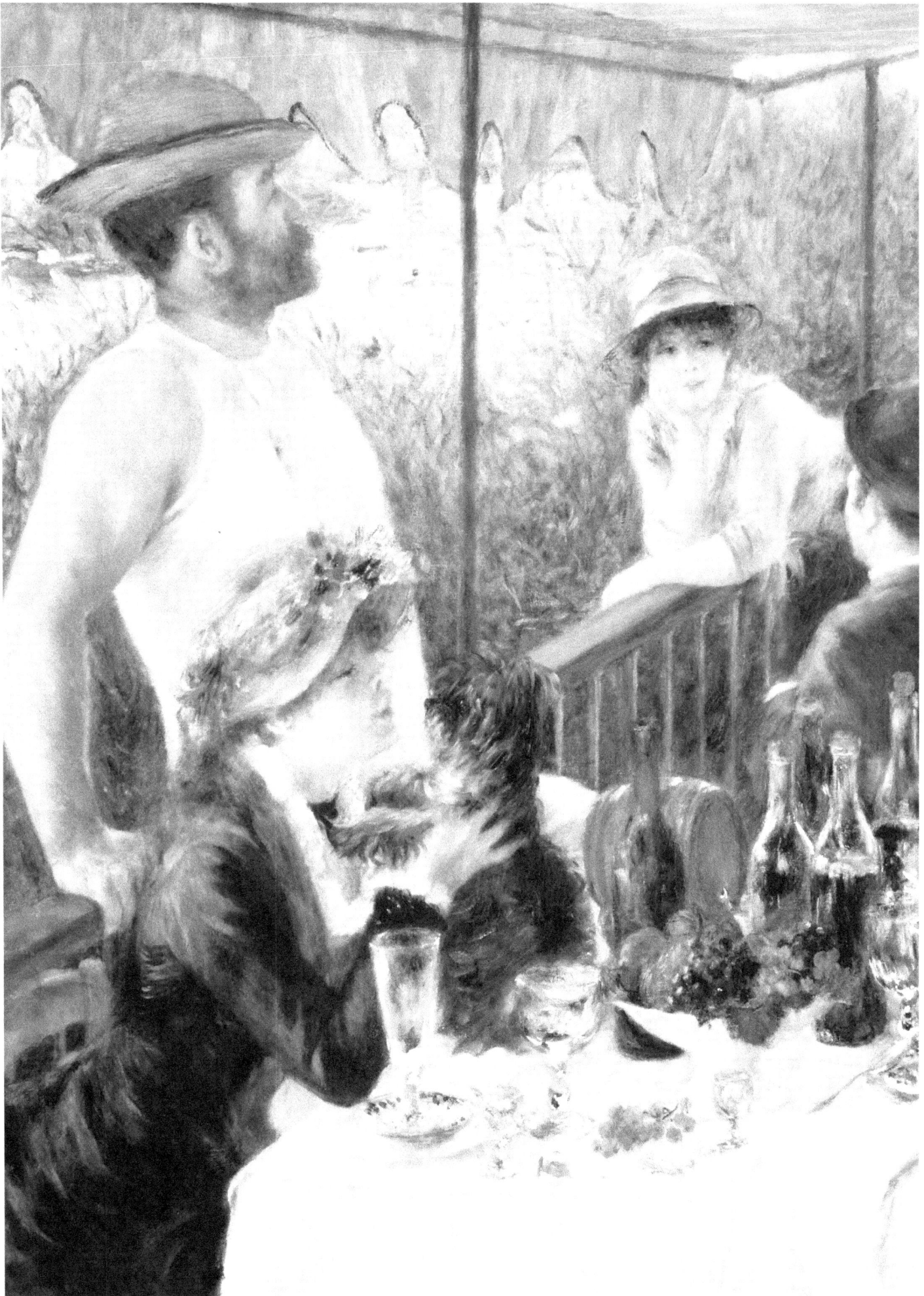

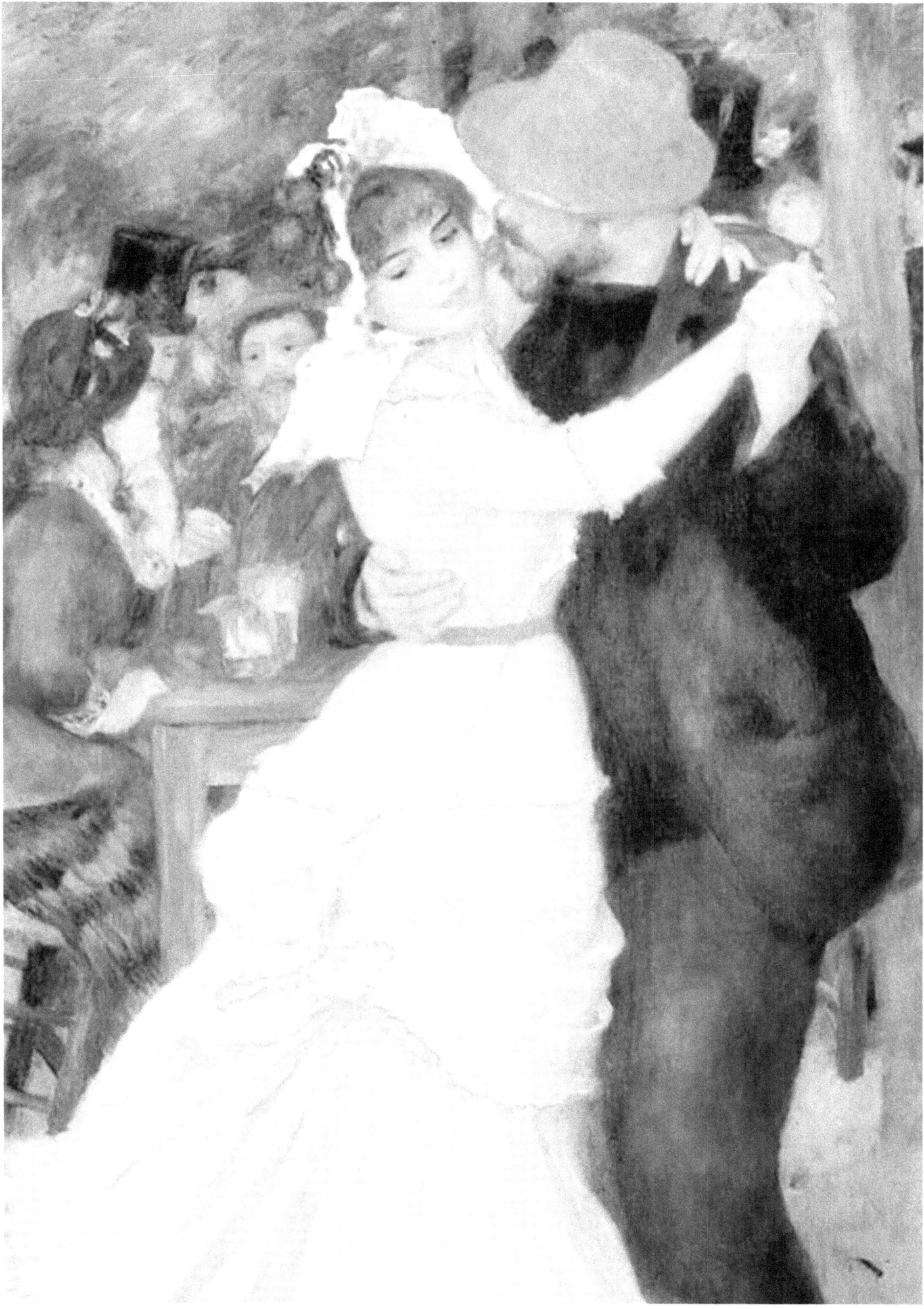

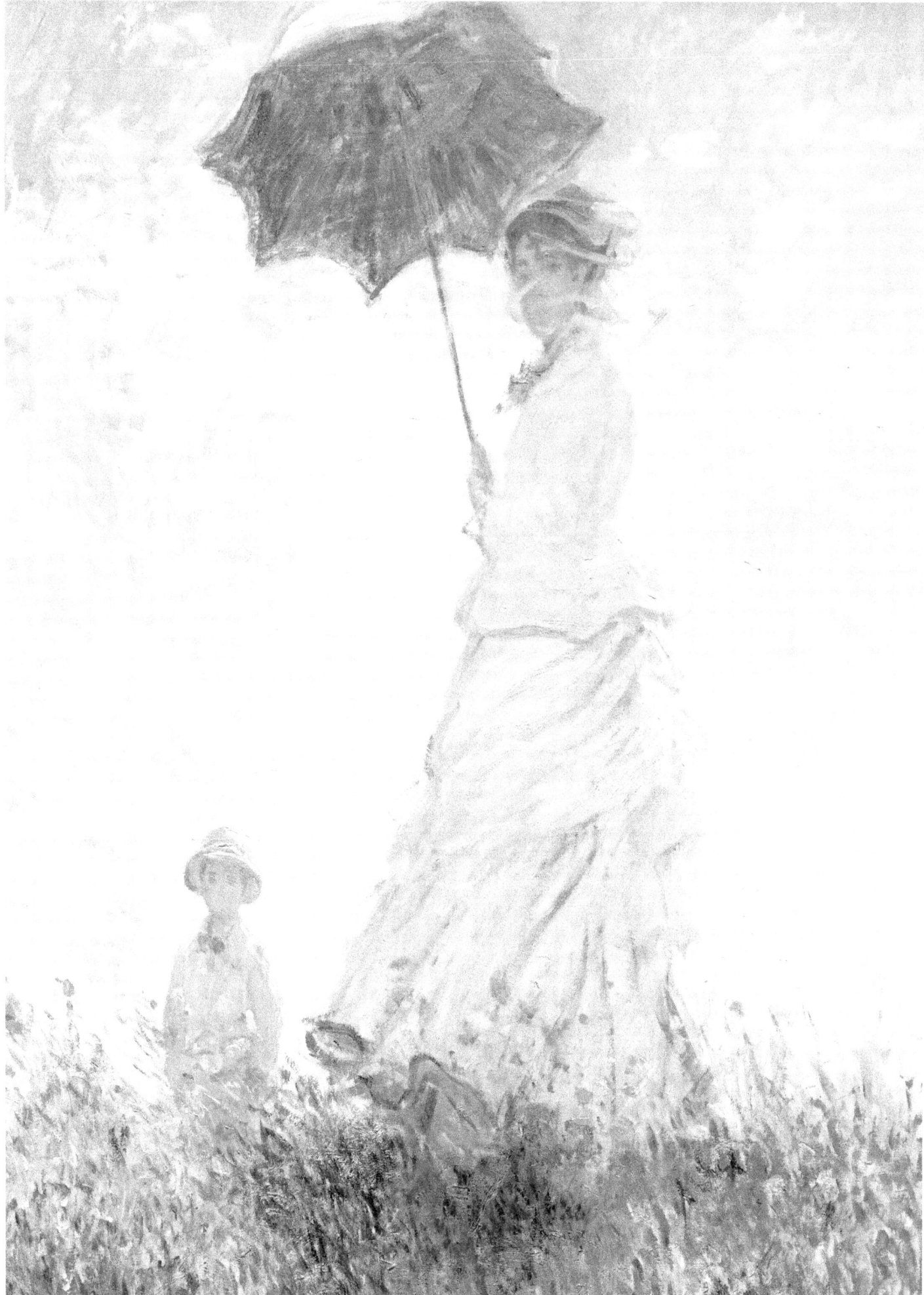

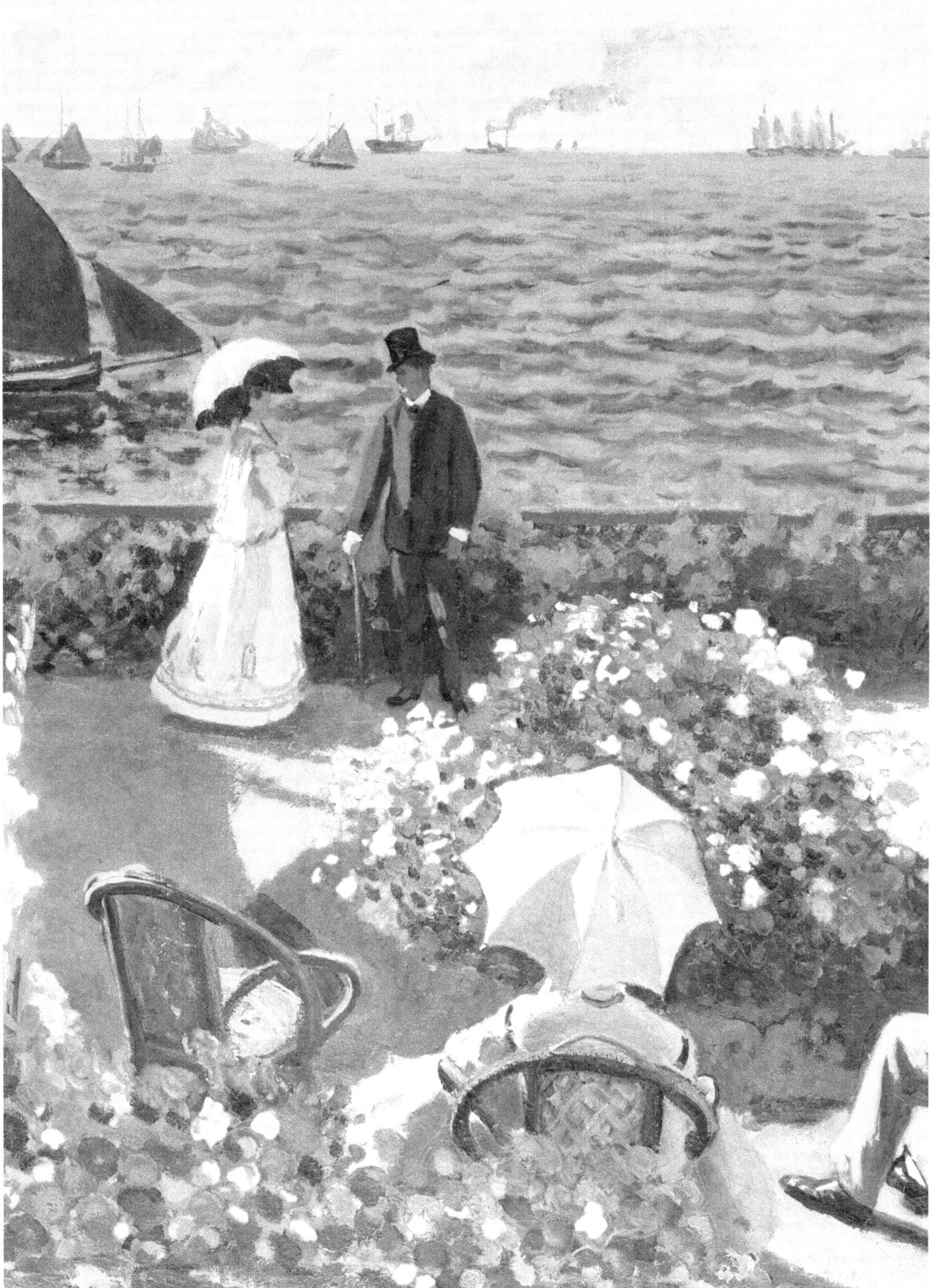

www.ingramcontent.com/pod-product-compliance
Lightning Source LLC
Chambersburg PA
CBHW081306180526
45170CB00007B/2582